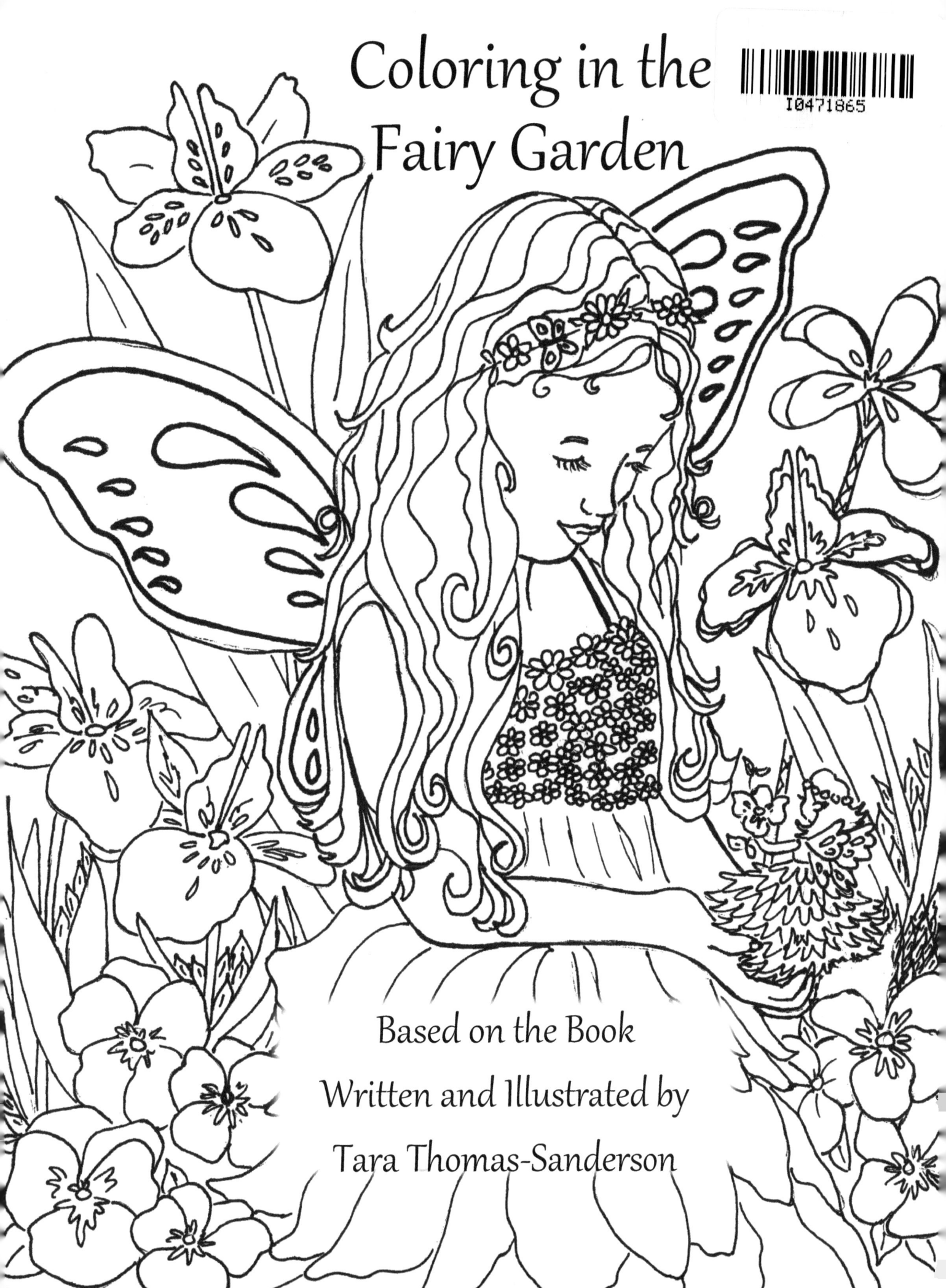

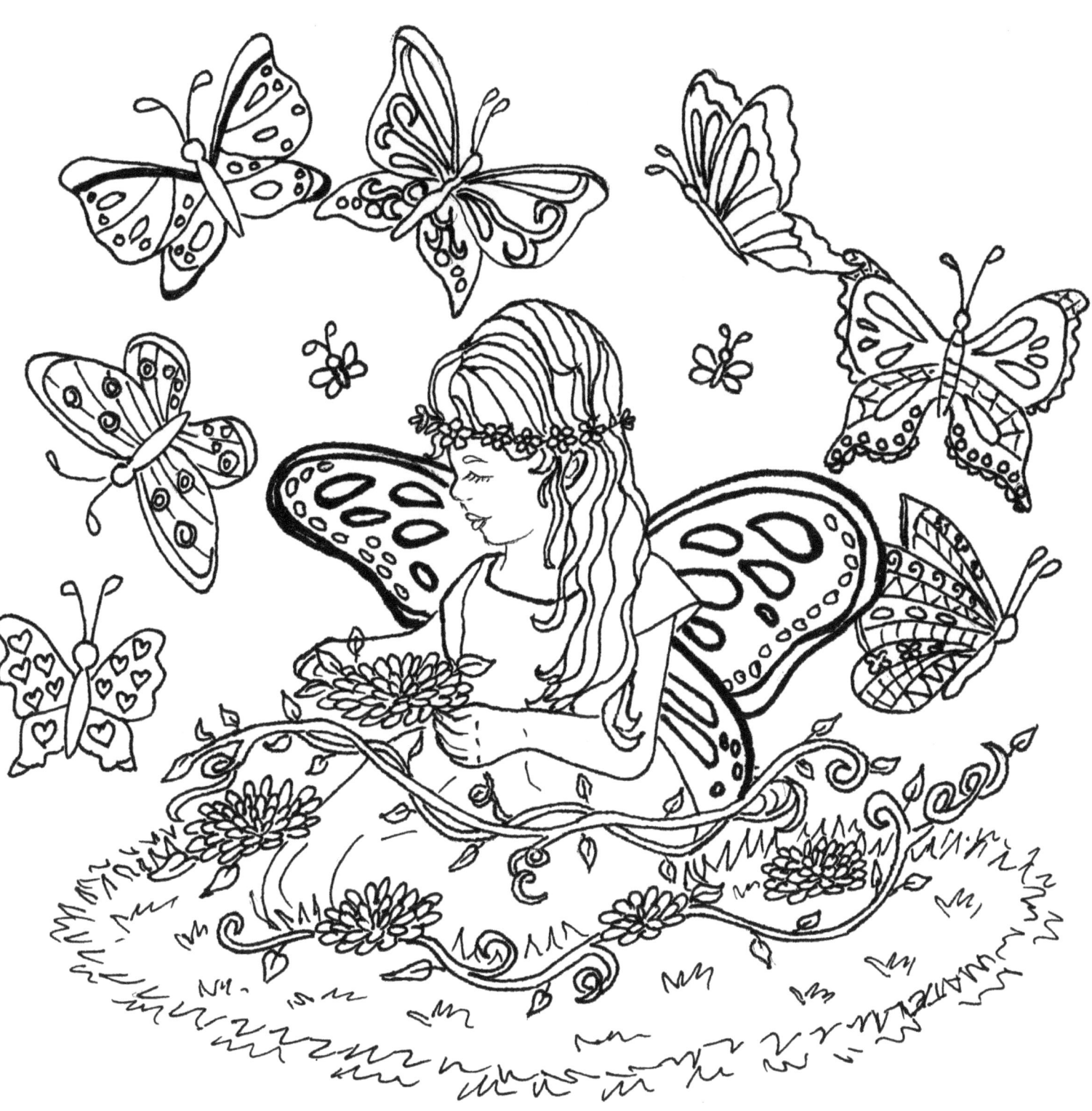

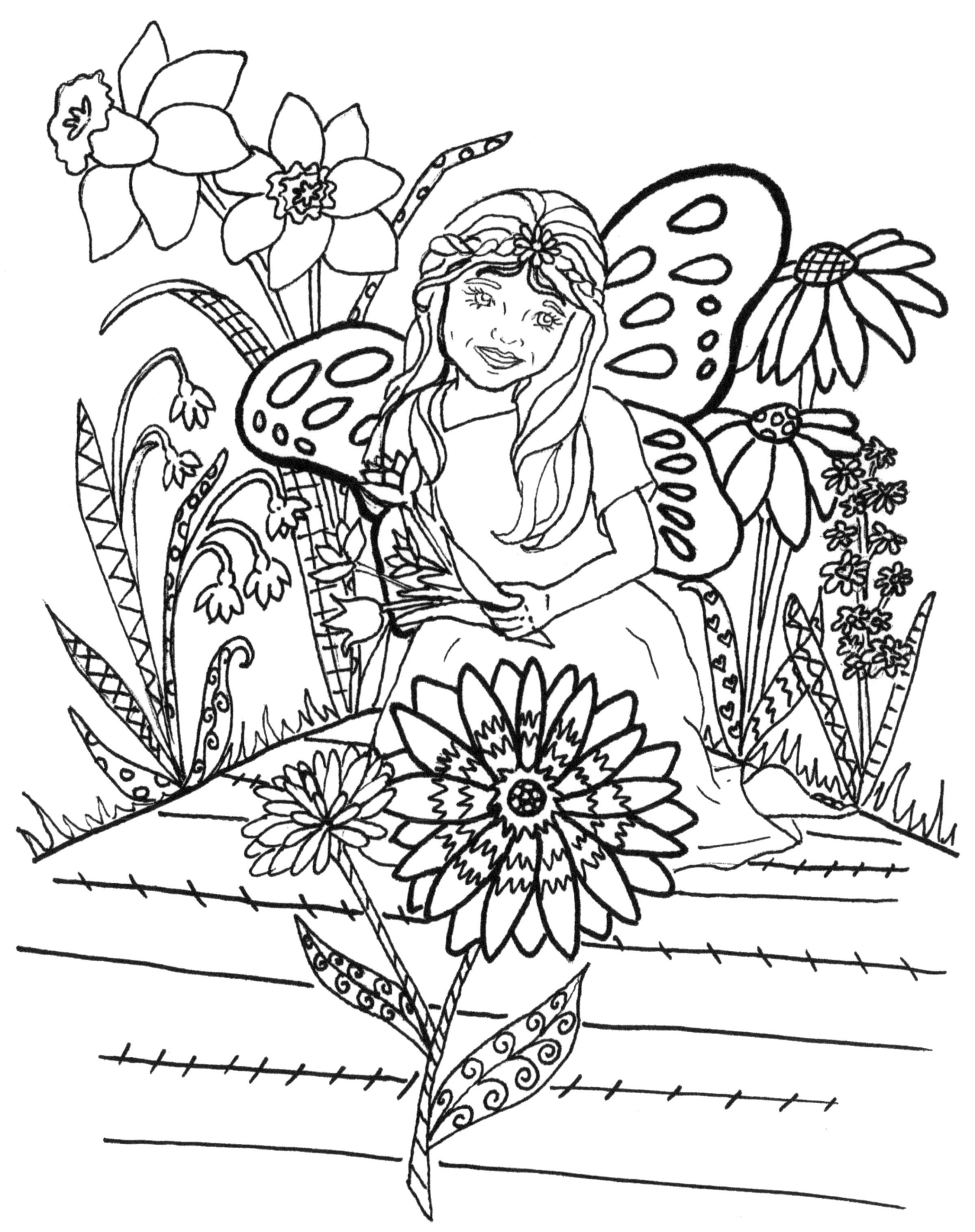

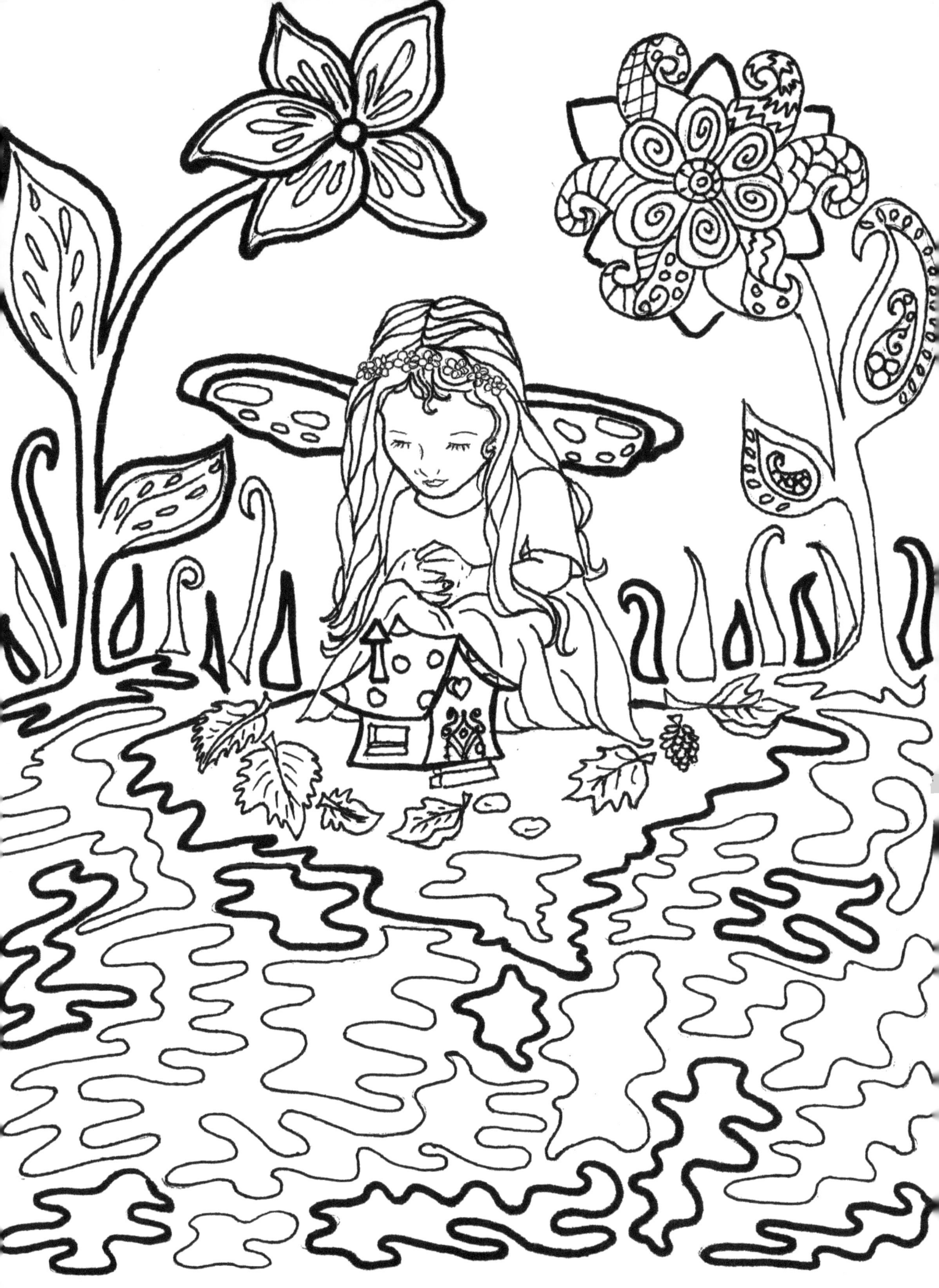

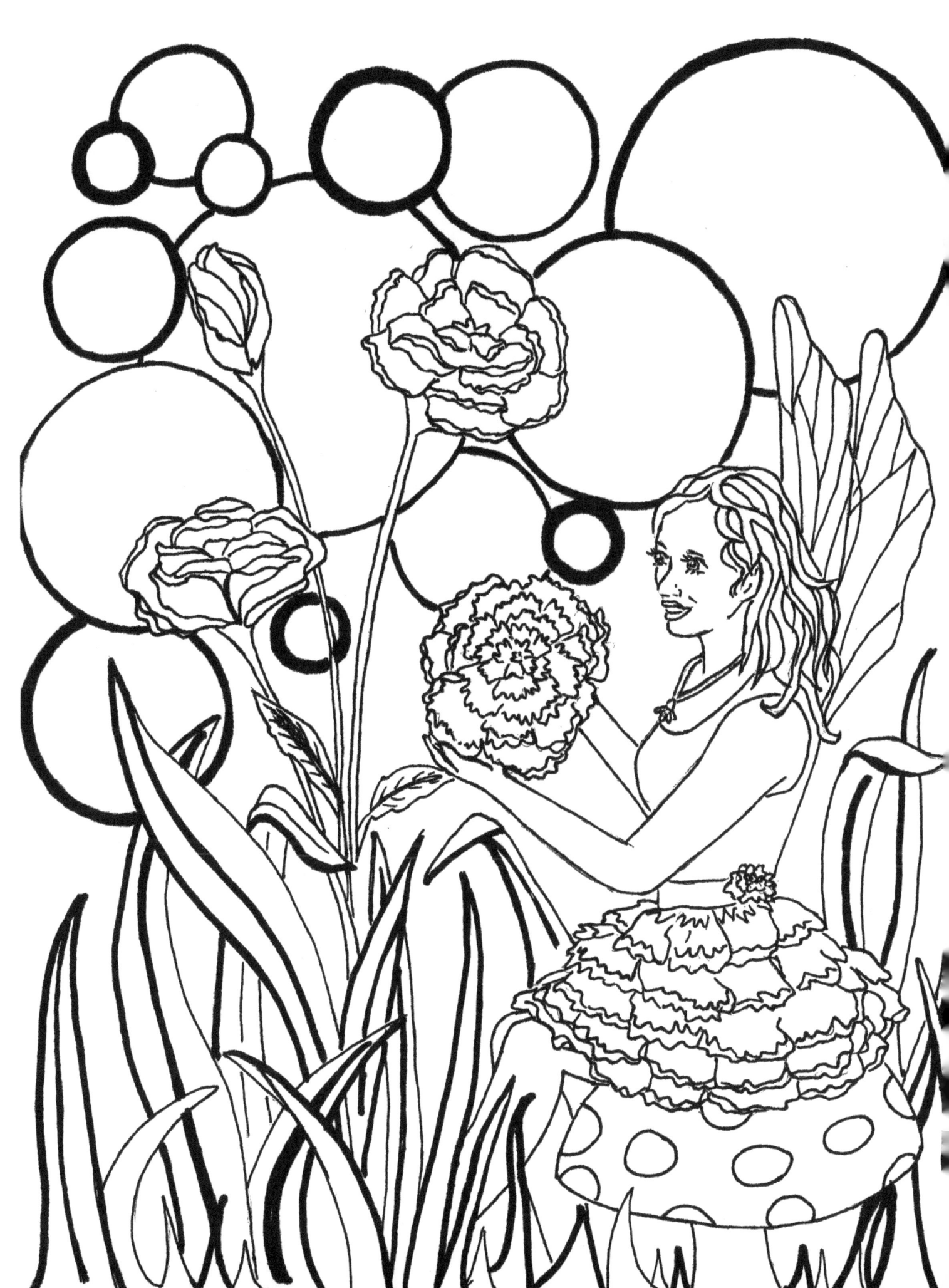

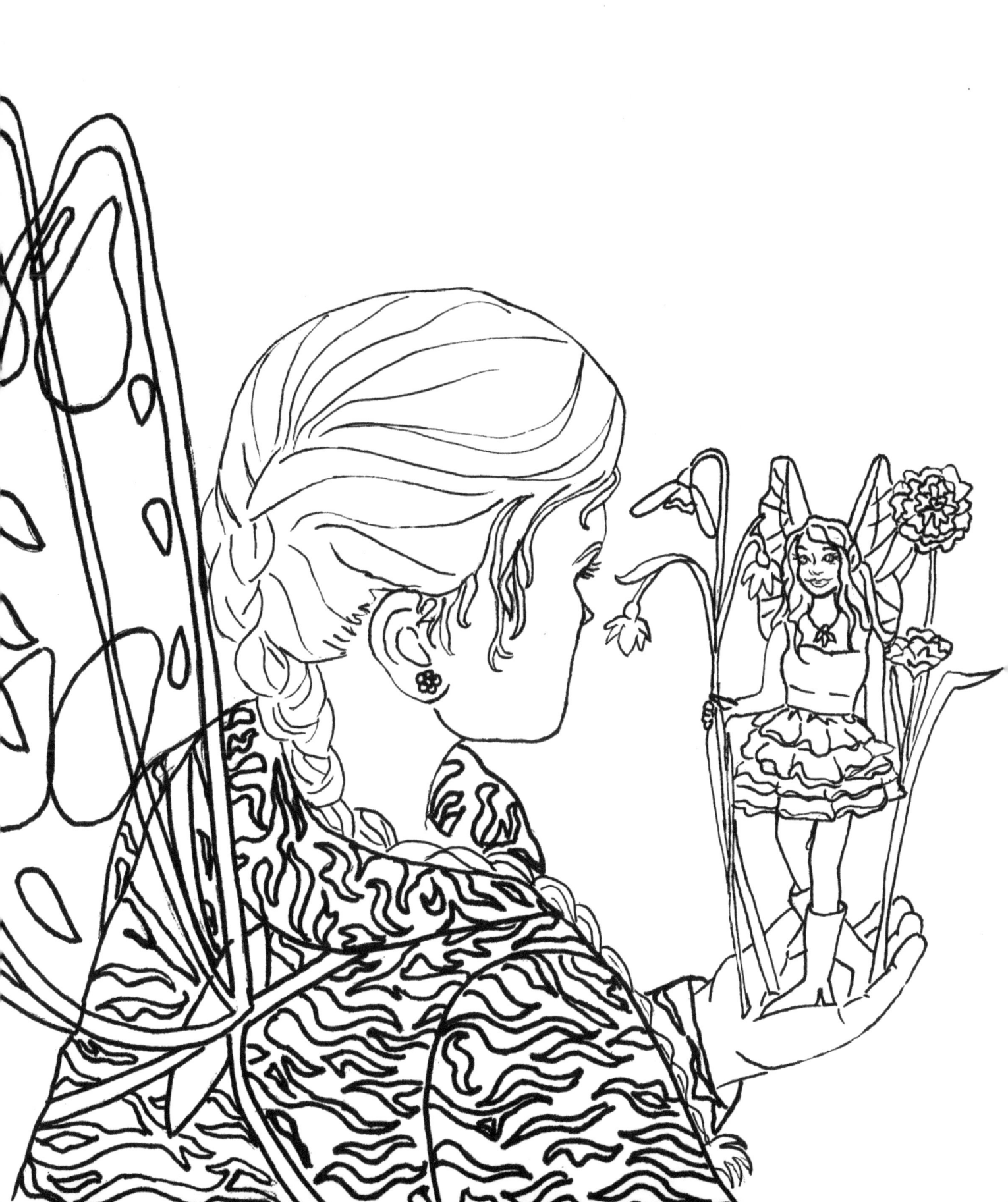

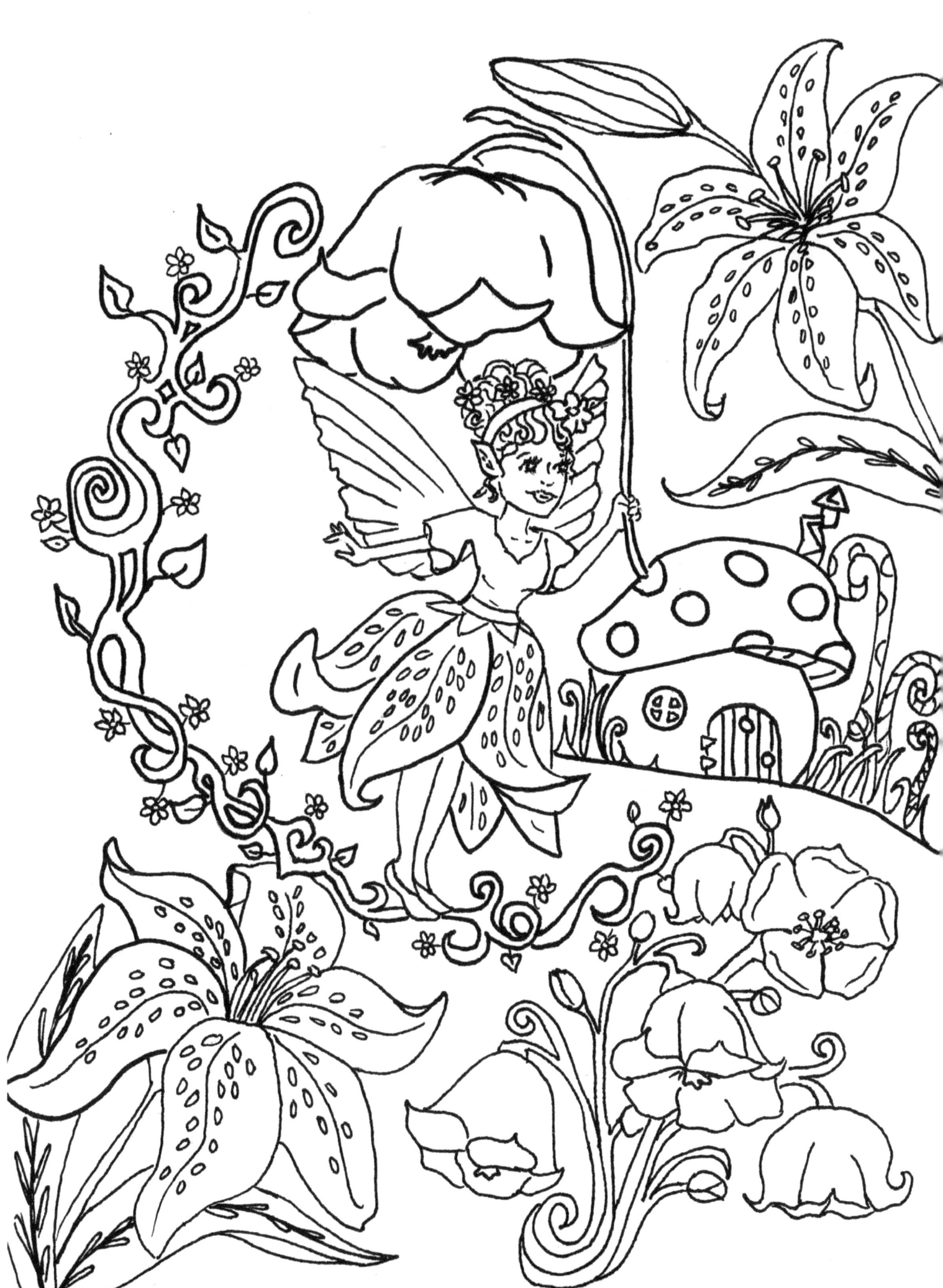

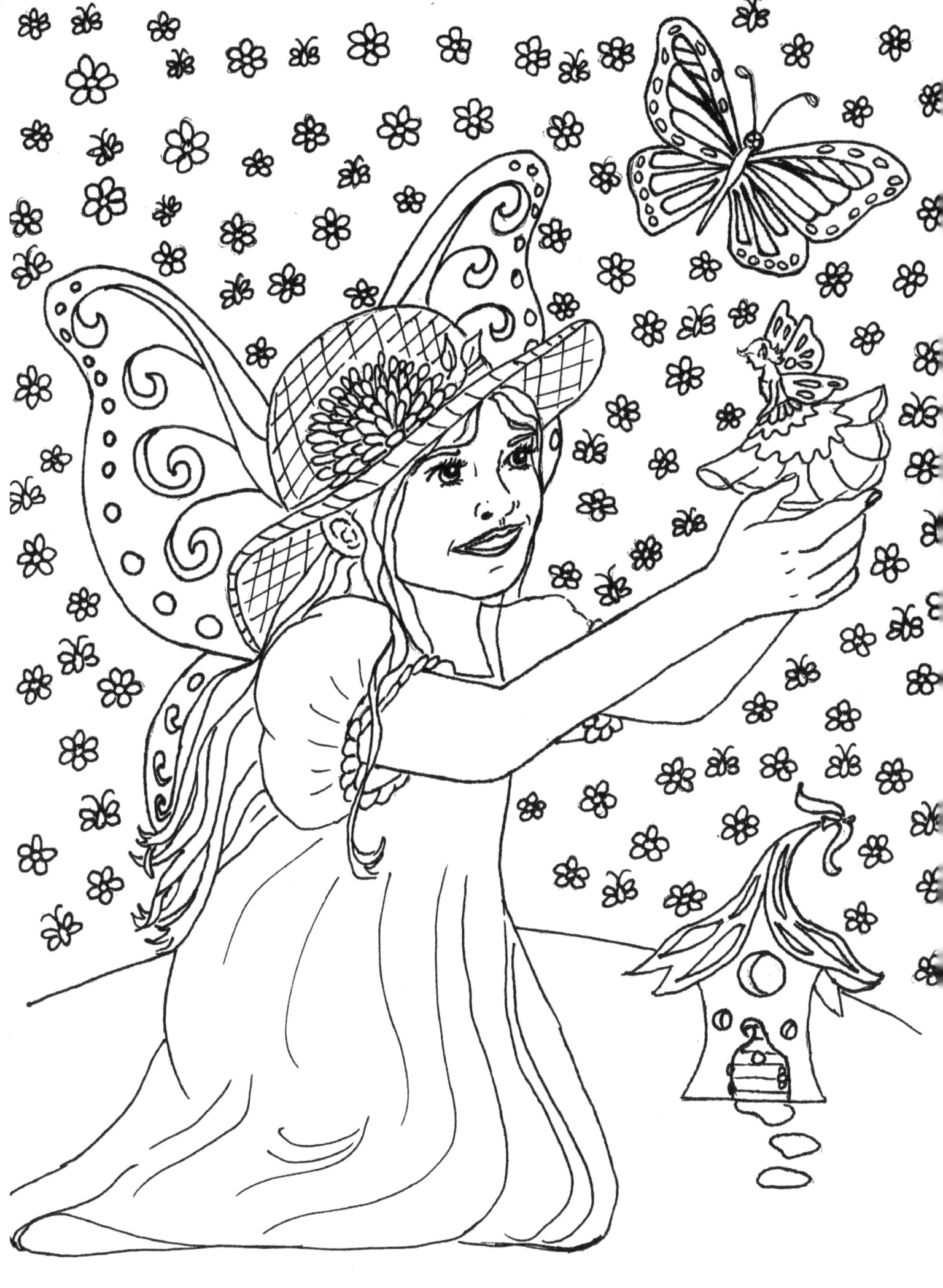

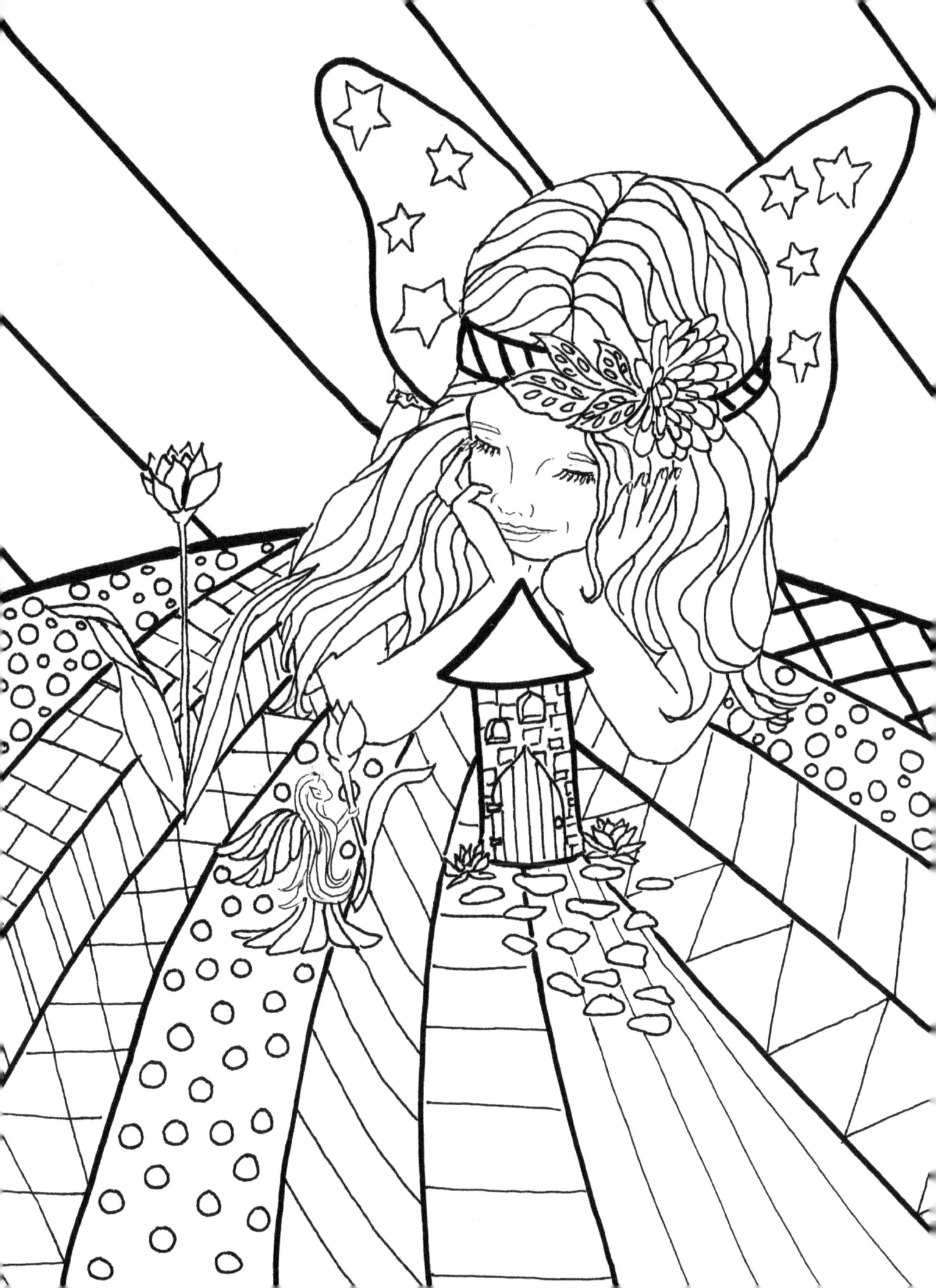

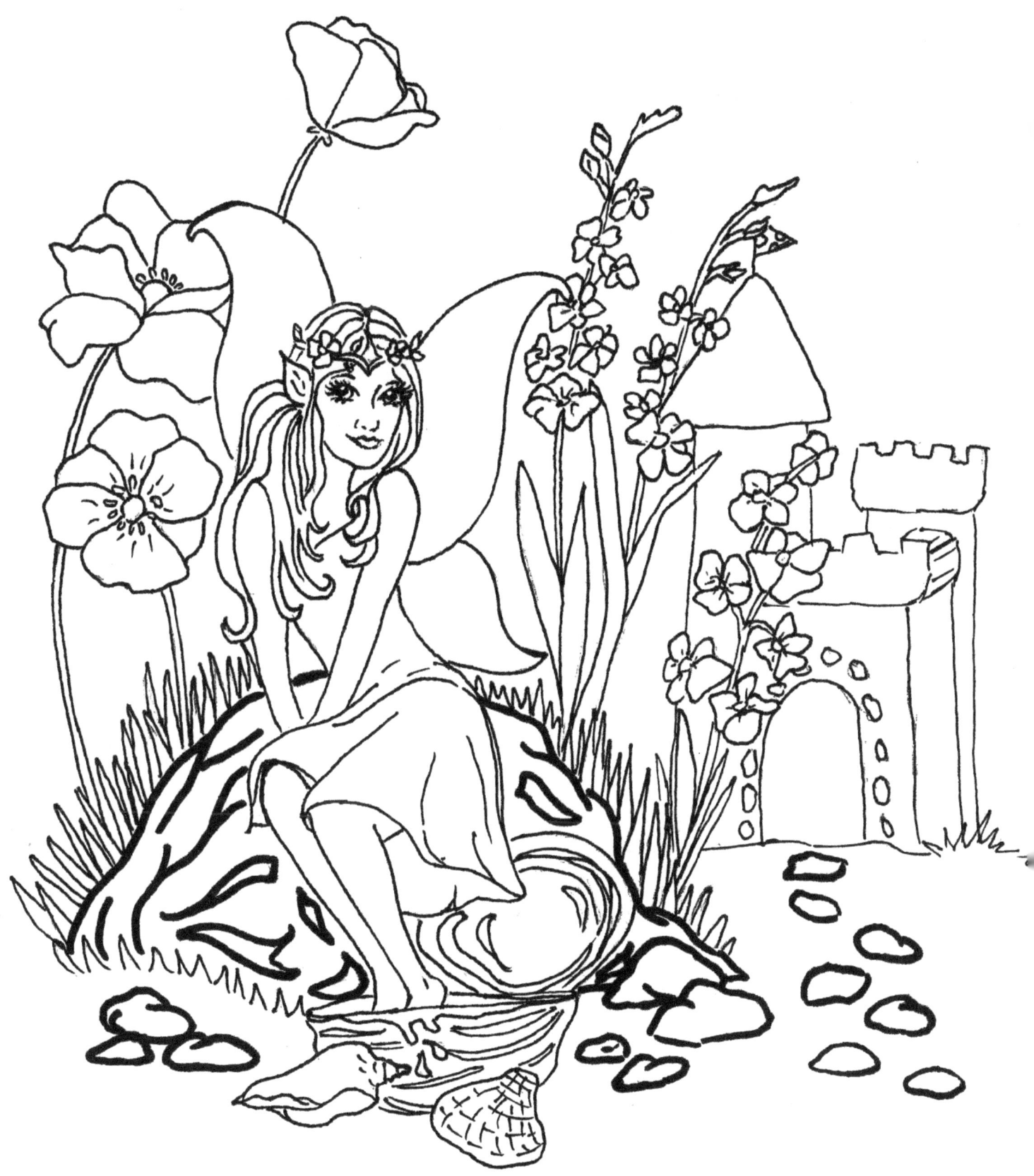

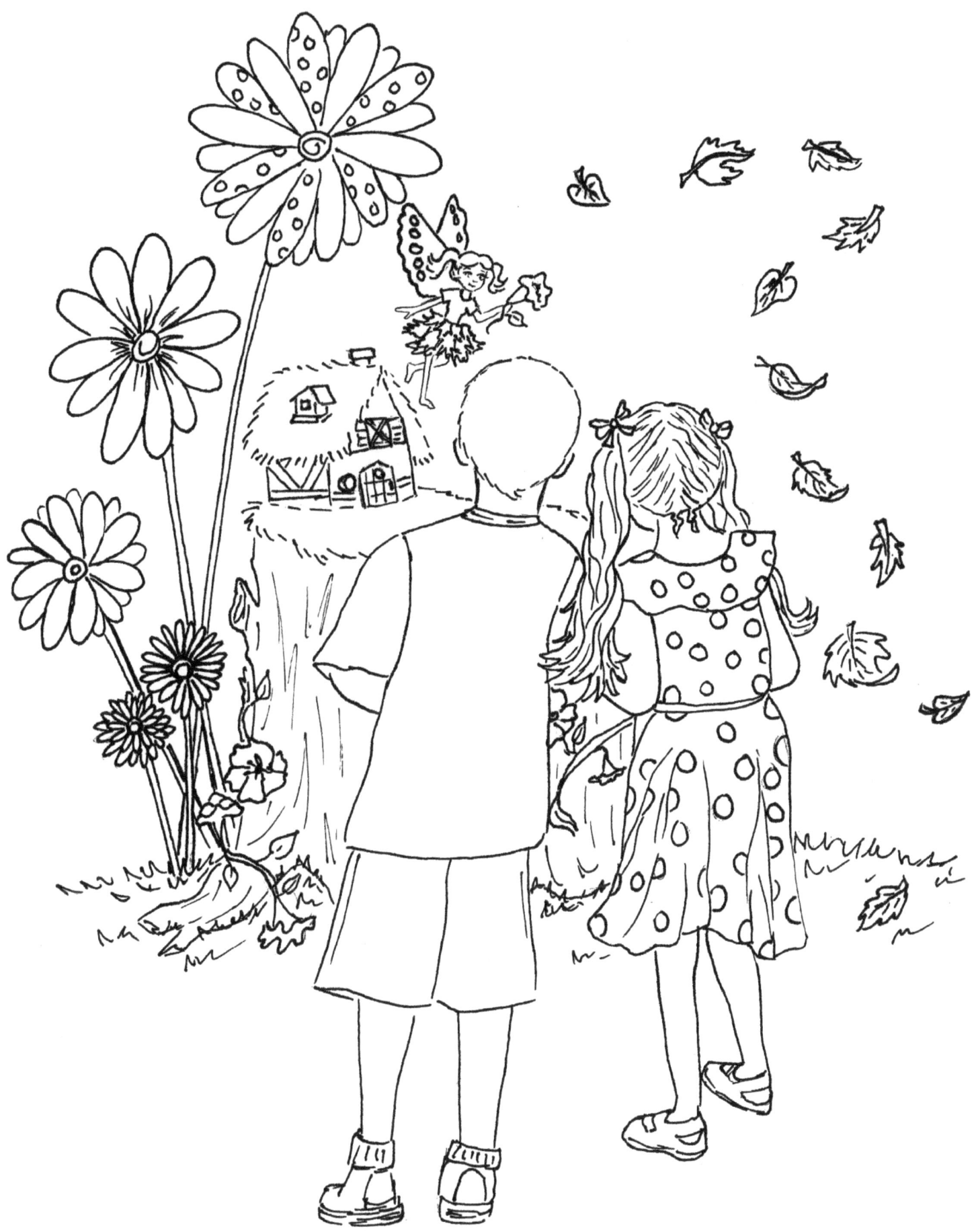

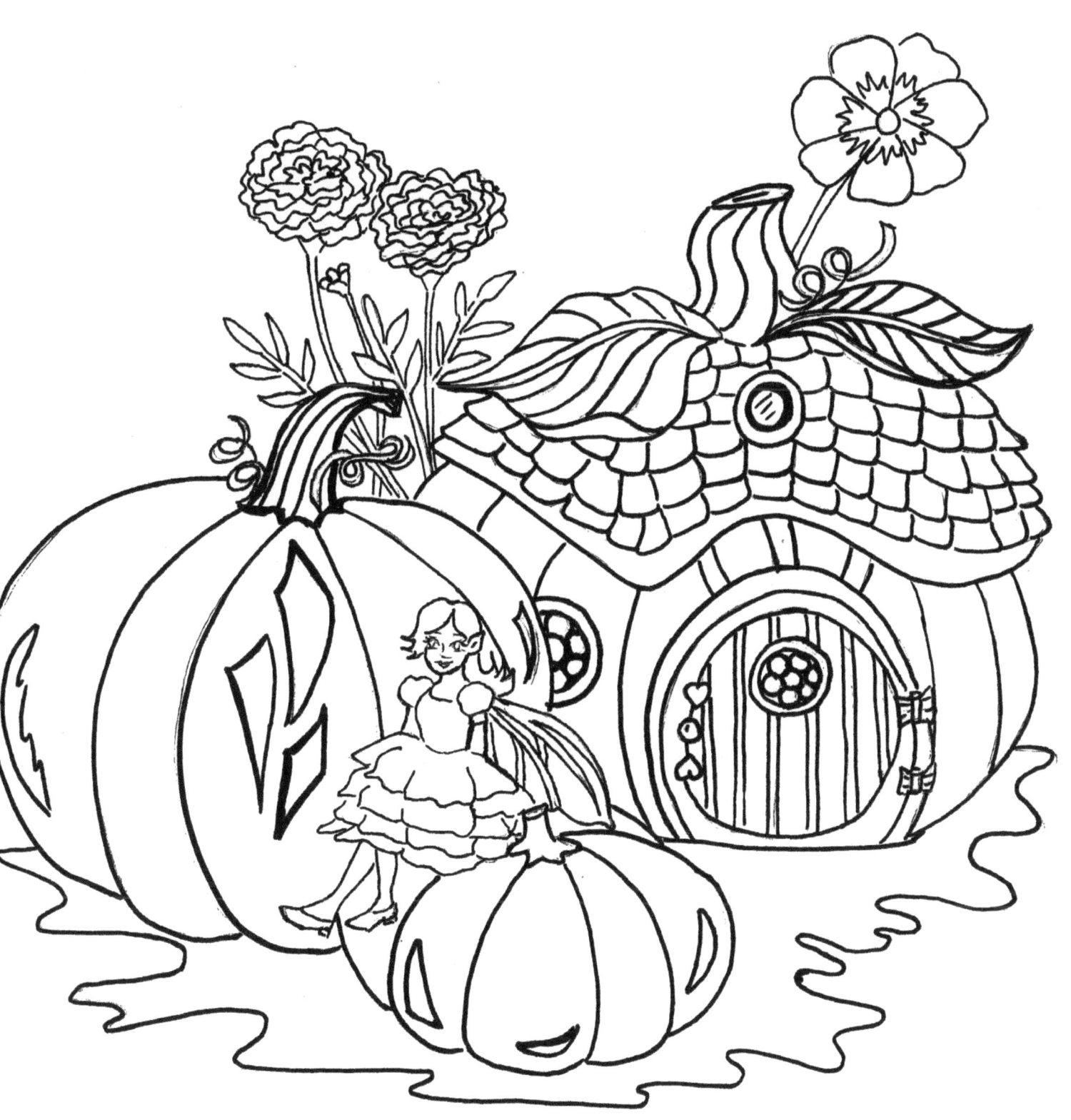

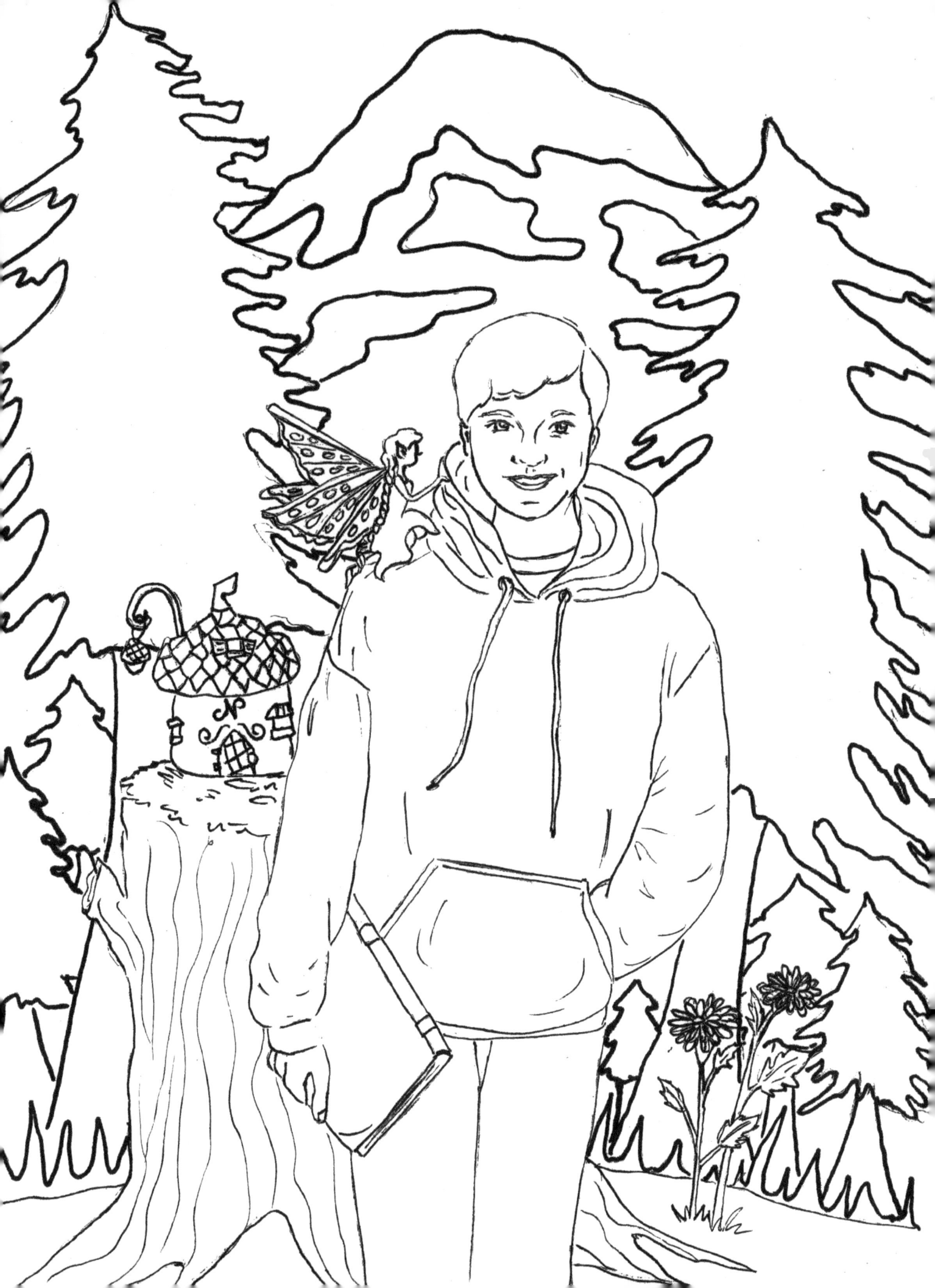

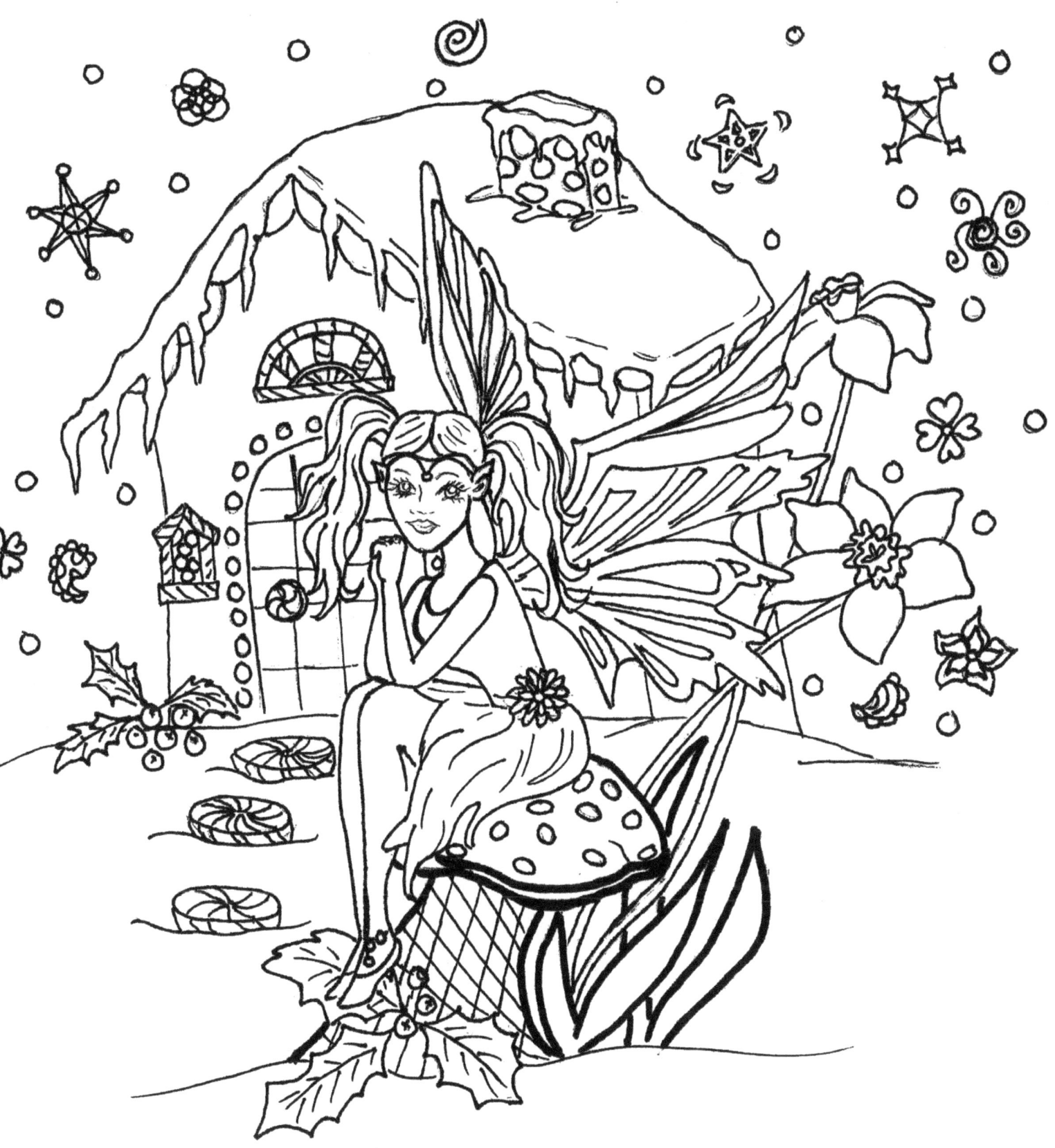

This coloring book is based on my picture book,

The Fairy Garden: A Discovery of Birth Flowers

I hope you enjoyed it!

If you would like to read the story to go along with the pictures and learn about birth flowers, you can find this and all of my books on www.SandersonStories.com or https://www.amazon.com/Tara-Thomas-Sanderson

(Available in ebook or paperback format)

Follow me on Facebook for upcoming books, events and more coloring pages!

www.Facebook.com/sandersonstories